Whimsical Woodland Creatures

Coloring for Everyone

Skyhorse Publishing

Artwork copyright © 2016:

Shutterstock/Oleg Golovnev (Intro image, White Rabbit)

Shutterstock/saraporn (Intro image, bears)

Shutterstock/Mark Bridger (Intro image, red fox)

Shutterstock/Vinata (Image 1)

Shutterstock/Dovile Kuusiene (Image 2, 12, 13, 30)

Shutterstock/sakushevajema (Image 3, 11, 17)

Shutterstock/Alexey Pushkin (Image 4)

Shutterstock/Hulinska Yevheniia (Image 5)

Shutterstock/soosh (Image 6)

Shutterstock/Zelena (Image 7, 44, 45)

Shutterstock/Ilya Plavinskiy (Image 8)

Shutterstock/oksanaSe (Image 9, 27)

Shutterstock/vanillamilk (Image 10, 23, 28, 29, 34)

Shutterstock/Beskova Ekaterina (Image 14)

Shutterstock/Undina (Image 15)

Shutterstock/vip2807 (Image 16)

Shutterstock/blackstroke (Image 18)

Shutterstock/Kateika (Image 19)

Shutterstock/Roman Poljak (Image 20, 35)

Shutterstock/Elena Medvedeva (Image 21)

Shutterstock/blackstroke (Image 22)

Shutterstock/Skrolan_Kabi (Image 24)

Shutterstock/NYgraphic (Image 25)

Shutterstock/Nuttapol (Image 26, 31, 36, 37)

Shutterstock/Maria_Galybina (Image 32)

Shutterstock/John T Takai (Image 33)

Shutterstock/lenkis_art (Image 38, 41, 42)

Shutterstock/Nuarevik (Image 39, 43)

Shutterstock/axako (Image 40)

Shutterstock/Sailin on (Image 46)

Skyhorse Publishing books may be purchased in bulk at special discounts for sales promotion, corporate gifts, fund-raising, or educational purposes. Special editions can also be created to specifications. For details, contact the Special Sales Department, Skyhorse Publishing, 307 West 36th Street, 11th Floor, New York, NY 10018 or info@skyhorsepublishing.com.

Skyhorse® and Skyhorse Publishing® are registered trademarks of Skyhorse Publishing, Inc.®, a Delaware corporation.

Visit our website at www.skyhorsepublishing.com.

10 9 8 7 6 5 4 3 2

Library of Congress Cataloging-in-Publication Data is available on file.

Cover design by Jane Sheppard
Cover artwork credit: Shutterstock/lenkis_art
Text by Chamois S. Holschuh

Print ISBN: 978-1-5107-0956-0

Printed in the United States of America

Whimsical Woodland Creatures:
Coloring for Everyone

Engaging in artistic activities—coloring included—is soothing as well as constructive. It provides a healthy stress outlet while exercising the right hemisphere of the brain (where all the imagination, spatial awareness, and color distinction happens). With that in mind, it's no wonder children are always encouraged to engage in arts and crafts. However, the need to flex our creativity never goes away, and sometimes we adults need a little reminder to make time for artistic pursuits. What better way to do so than by spending time with your old pals: foxes, owls, raccoons, deer, bears, and many more!

Woodland animals have romped through our imaginations since we were young. Whether we were poring over the pages of *Winnie the Pooh*, *The Wind in the Willows*, and *Watership Down*, or glued to the screens of *Bambi* and *The Fox and the Hound*, we were fascinated by the furry as well as the fierce creatures that call the forest home. As we grew, our beloved friends were often forgotten in favor of other interests. (The same goes for coloring, which coincidentally is most likely the first art medium we all practiced while still enthralled by our four-legged friends.) As busy adults with careers and families to occupy our time, getting back to nature is something all of us think about every once in a while. Though, it's not always possible to go for a hike. Some of us live in the city, some of us never seem to have time during the daylight hours, some of us love nature but don't love its bugs—we can come up with excuses until we run out of space for this introduction. Nevertheless, it's time to return to the woods and get reacquainted.

With this coloring book, you can let your imagination roam over the mountains and across the brook, all from the comfort of your favorite arm chair. Maybe you'll

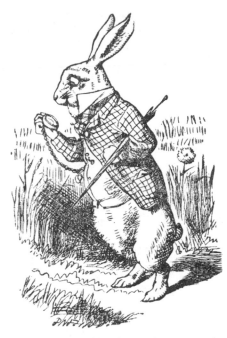

The White Rabbit from *Alice in Wonderland* by Lewis Carroll.

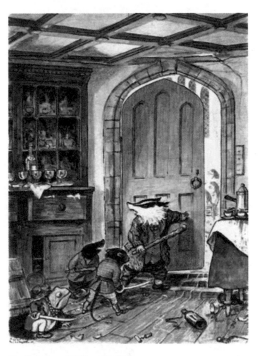

Badger and his neighbors prepare to attack a party of weasels in *The Wind in the Willows* by Kenneth Grahame.

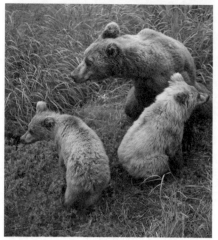

Bear cubs stay with their mother until they are 1½–2 years old.

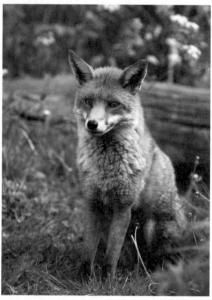

The red fox (*Vulpes vulpes*) can be found across the entire Northern Hemisphere.

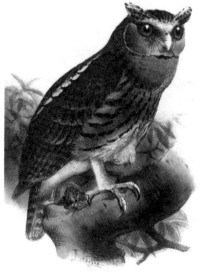

Owls have binocular vision and an acute sense of hearing, making them exceptional hunters.

even be inspired to do a little research and get to know these critters even better! For example, did you know that during a bear's deepest hibernation phase, its heart rate can slow down to as few as eight beats per minute? That's ninety percent slower than its normal summer heart rate! Bear cubs stay with their mother until they are between one and a half and two years old. Even after they leave mom, young bear siblings may stay together for safety as long as a whole year while they learn to be increasingly independent. In other animal trivia, a group of foxes is called a "skulk" or a "leash" while a group of owls is called a "parliament." And speaking of owls, these nocturnal hunters can rotate their necks 270 degrees, a necessary ability since their tube-shaped binocular-vision eyes are immobile. These are just a few fascinating facts about this coloring book's honorees! As you color, google away to your animal-loving heart's content and find out more!

In the meantime, we've collected a wondrous assortment of woodland creatures that your adult sensibilities can appreciate while still indulging your inner artist with the glee of coloring. Whether it's the rain, the mosquitoes, or the distance that's keeping you out of the woods, you can still revel in the majesty of it all. In the first few pages, we've provided a pre-colored guide to the designs that comprise this collection. These pre-colored versions are by no means prescriptive; feel free to imitate or innovate your own color choices as you see fit. Gather your colored pencils, reminisce, relax, and enjoy! You'll realize you never really left these forest critters behind.

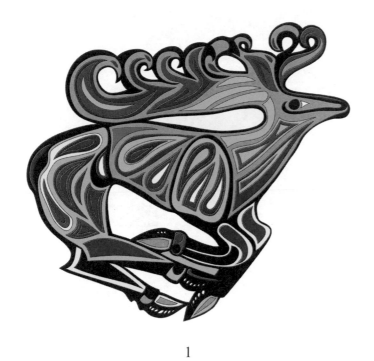

1

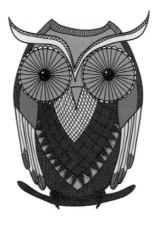
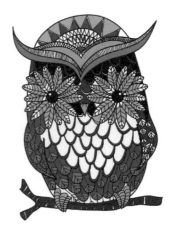

2

3

4

5

6

7

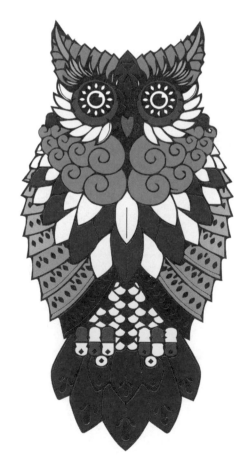

8

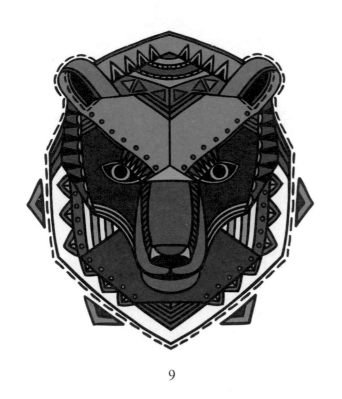

9

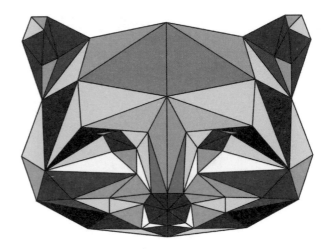

10

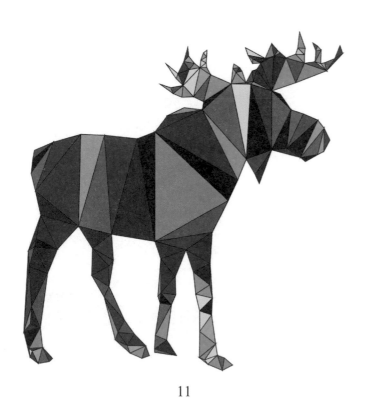

11

12

13

14

15

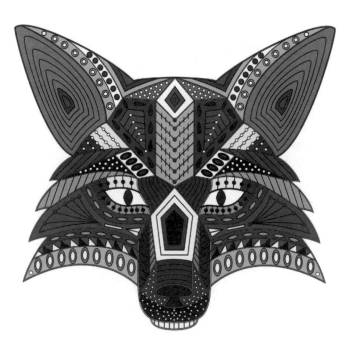

16

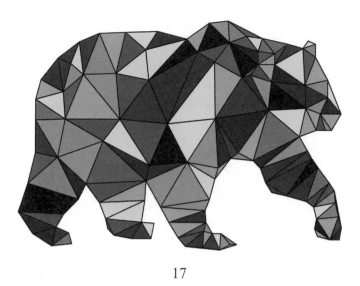

17

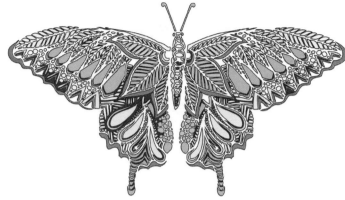

18

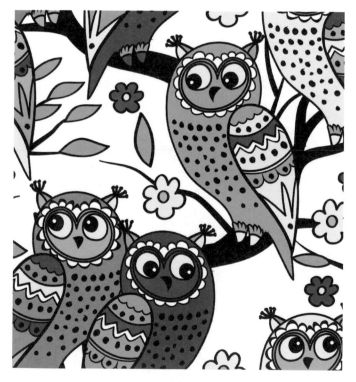

19

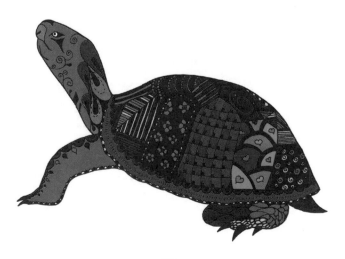

20

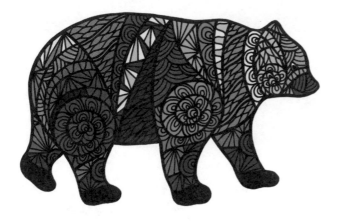

21

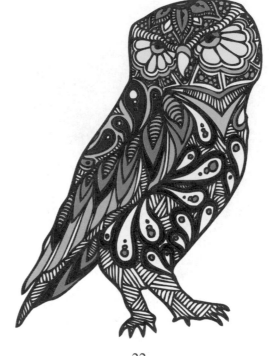

22

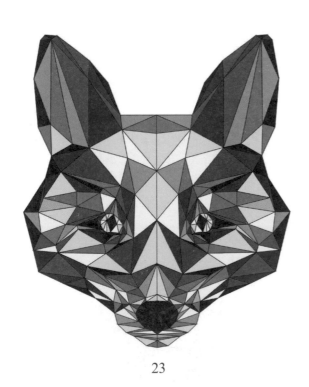

23

24

25

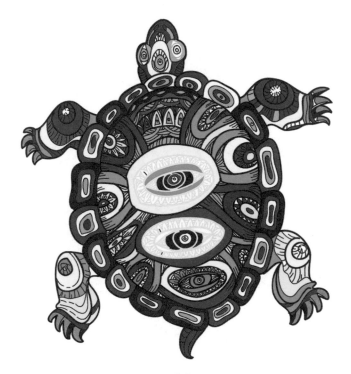

26

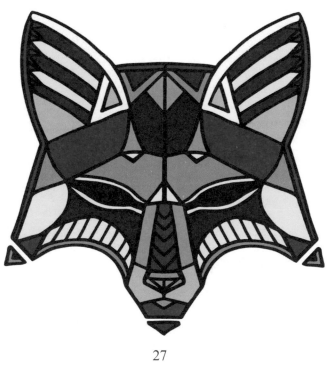

27

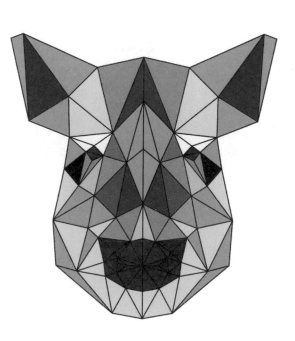

28

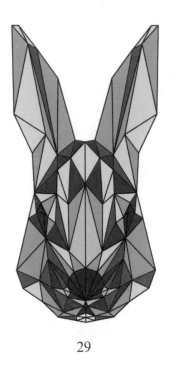

29

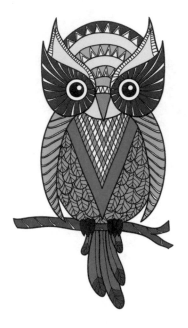

30

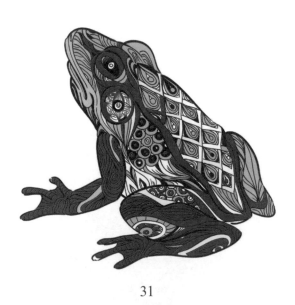

31

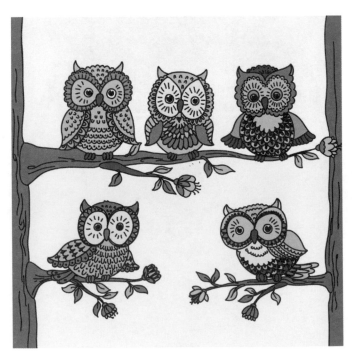

32

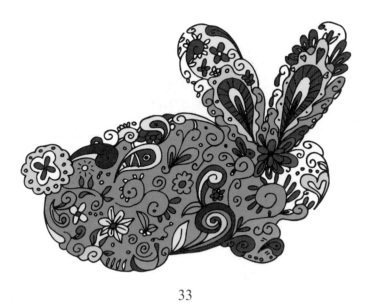

33

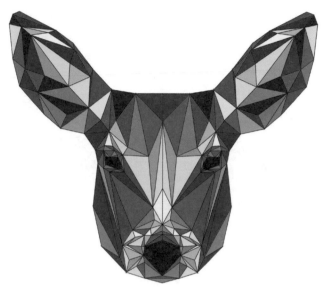

34

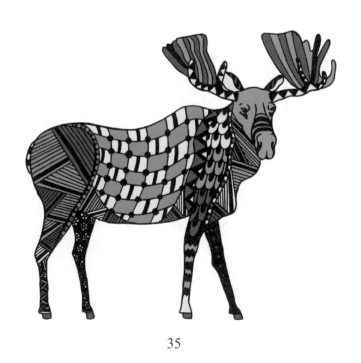

35

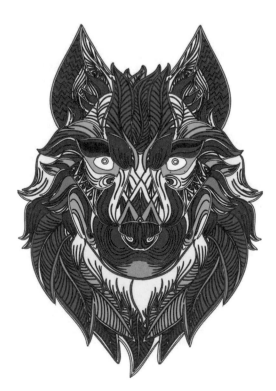

36

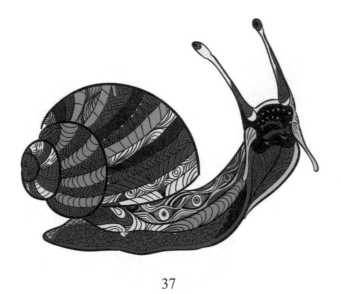

37

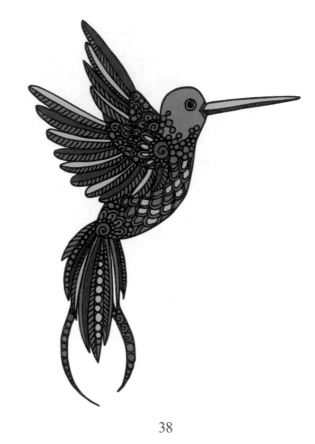

38

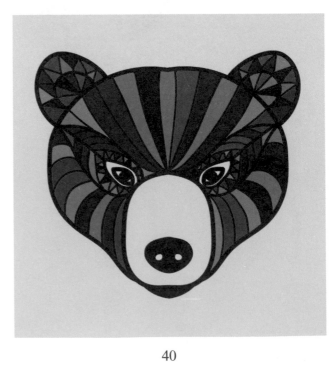

39

40

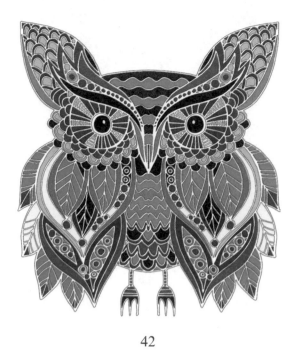

42

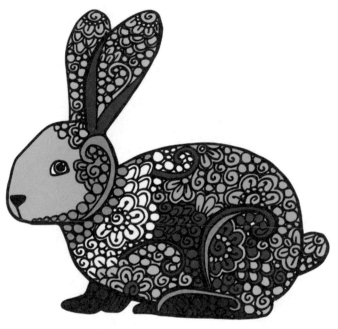

41

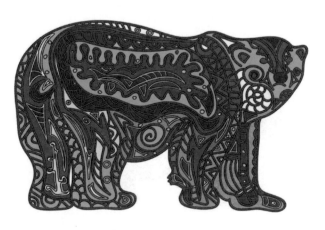

43

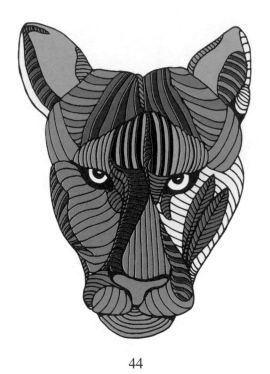

44

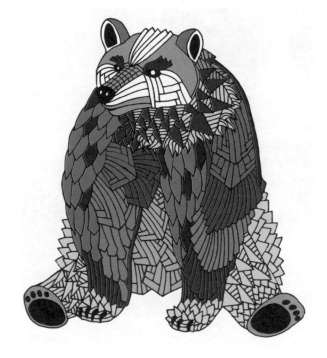

45

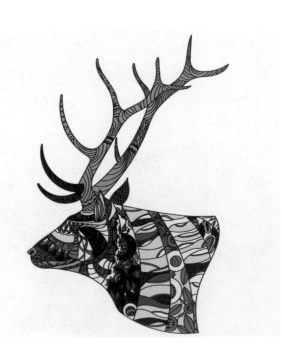

46

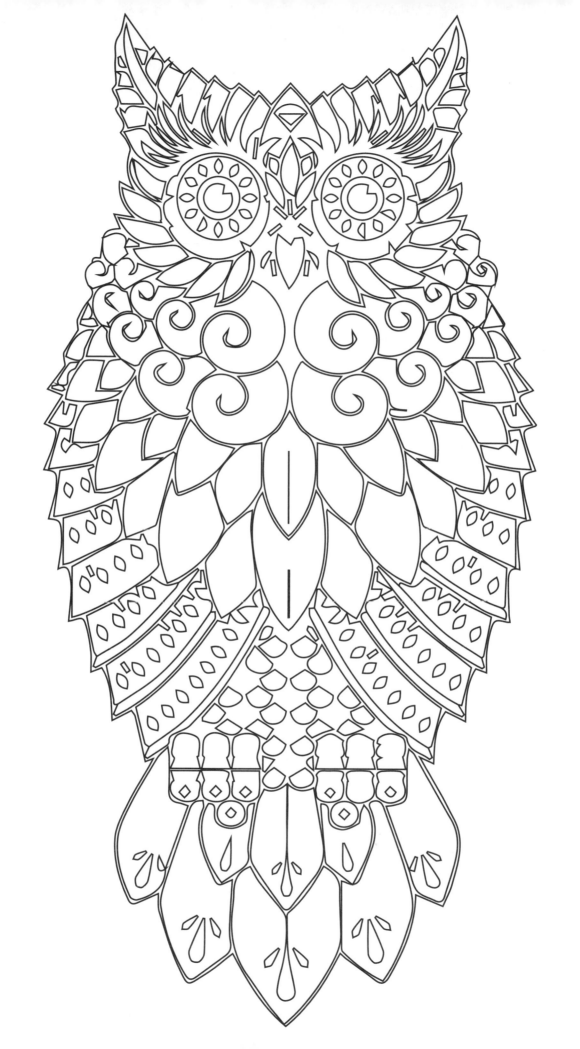

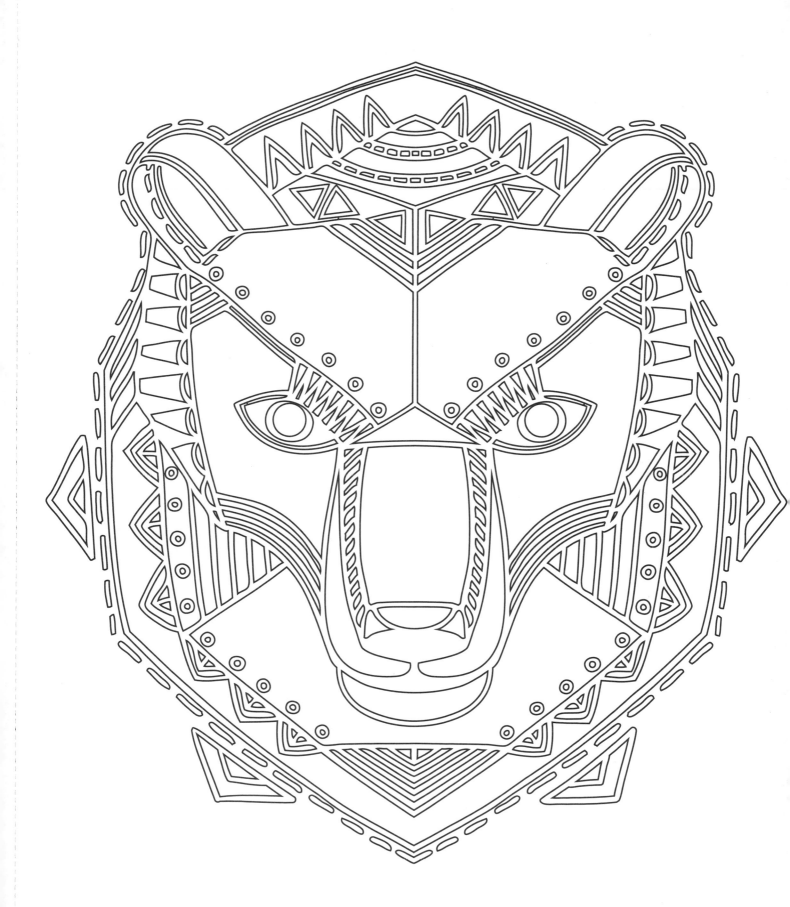

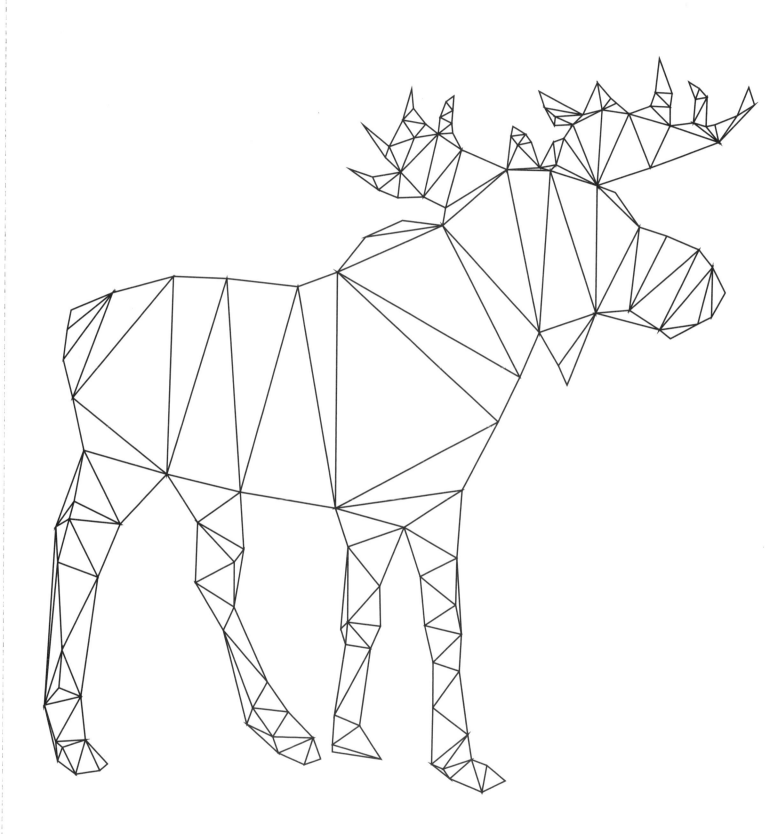

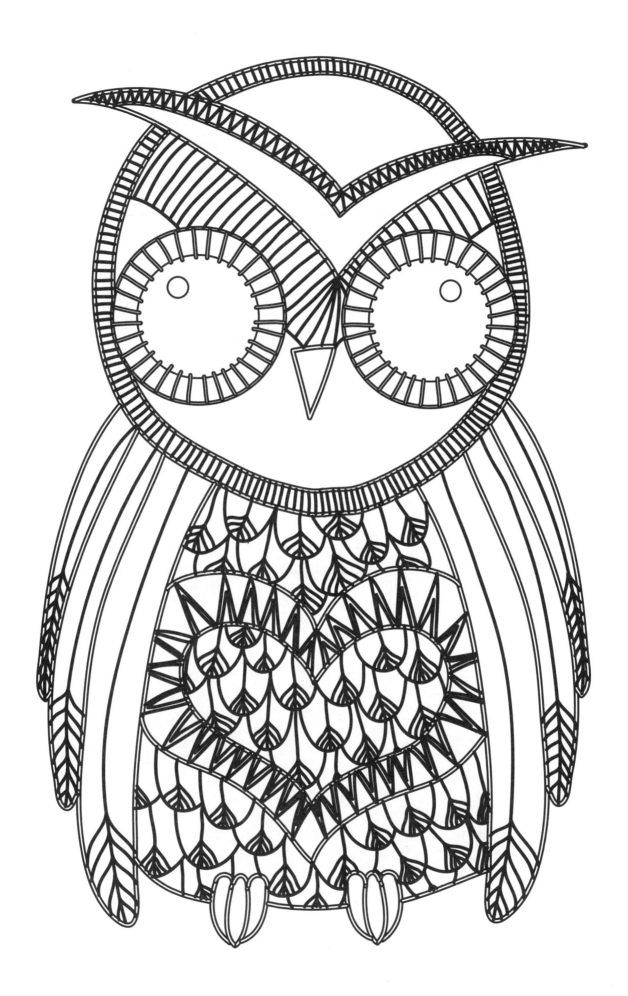

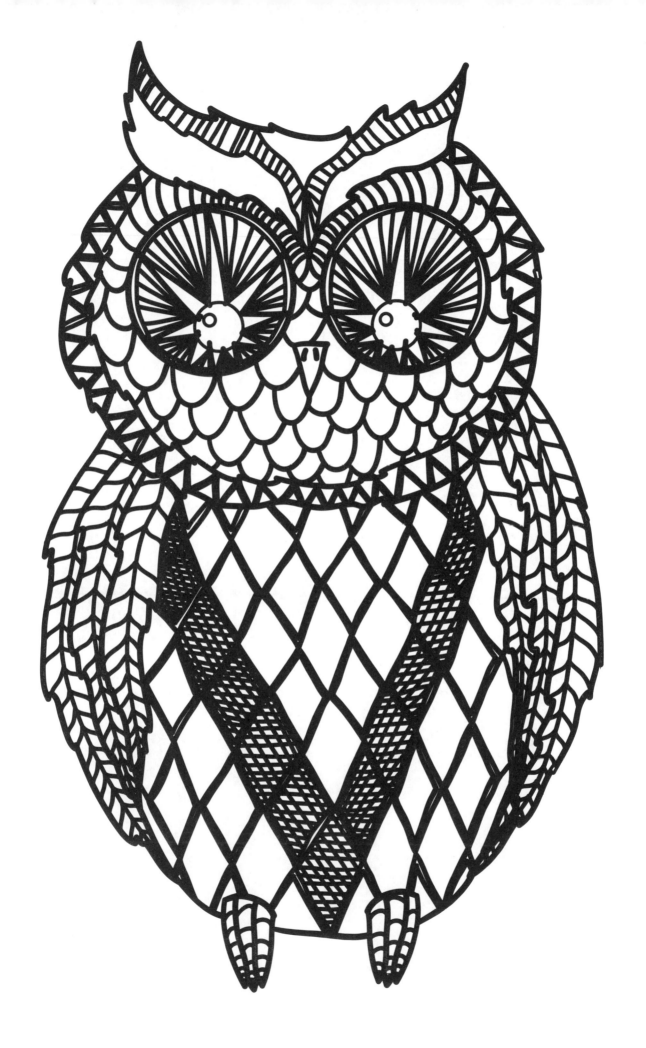

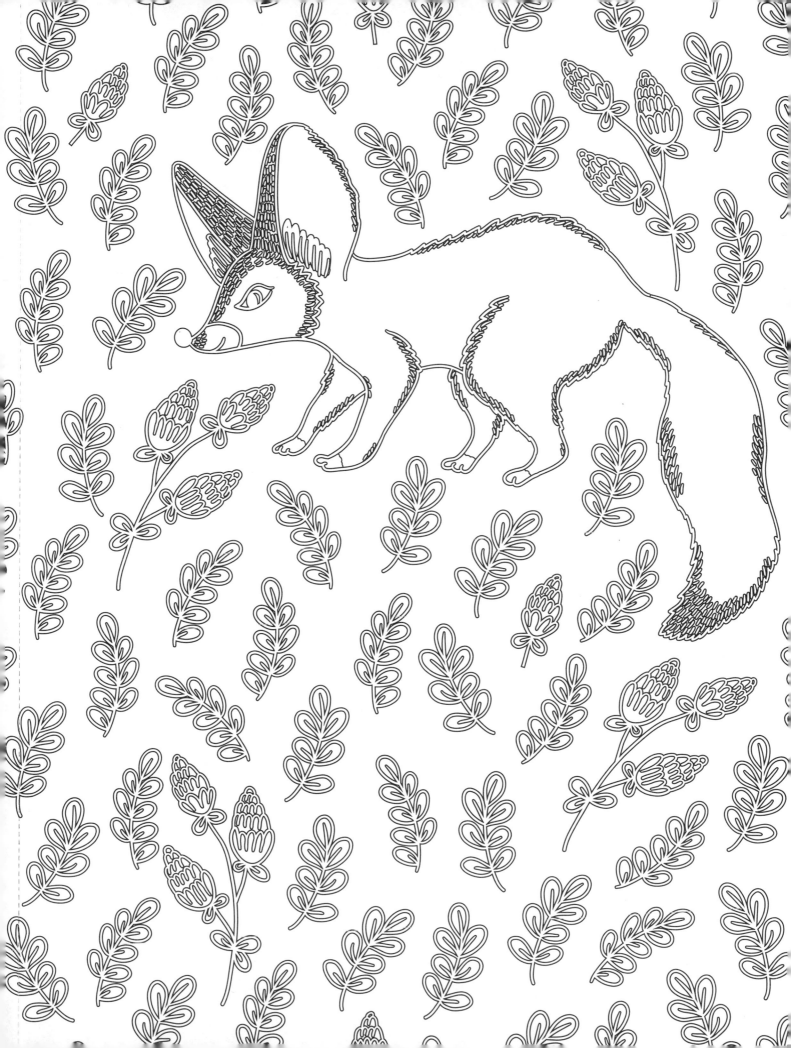

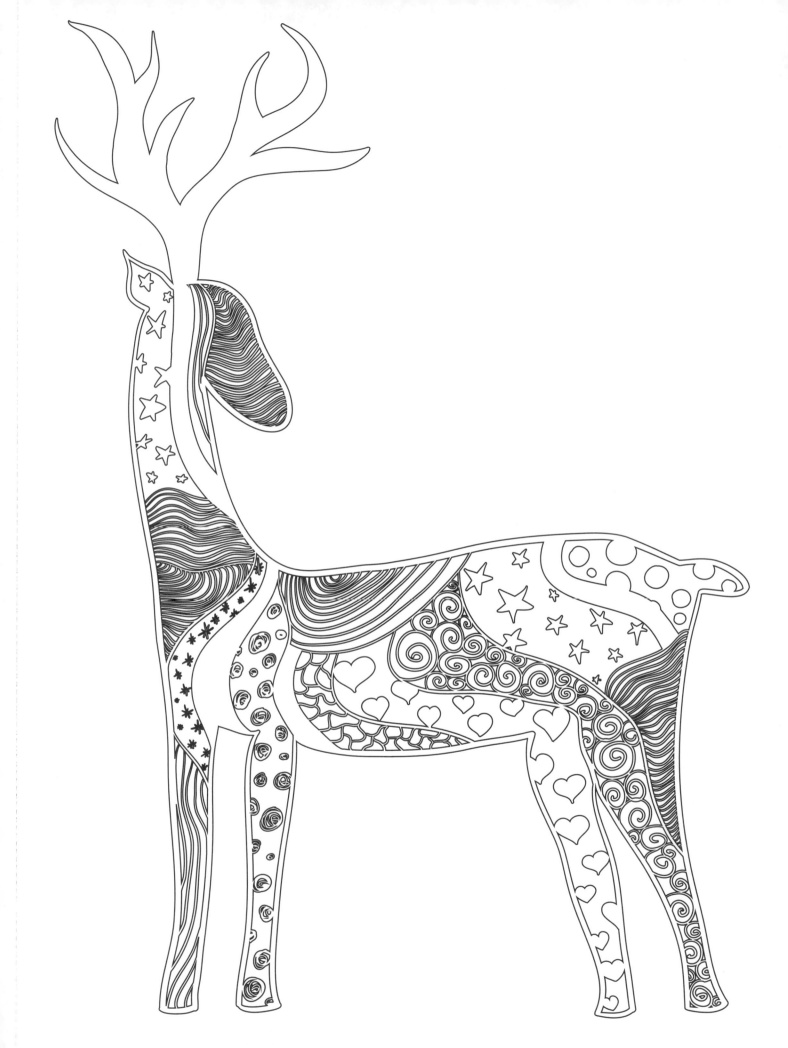

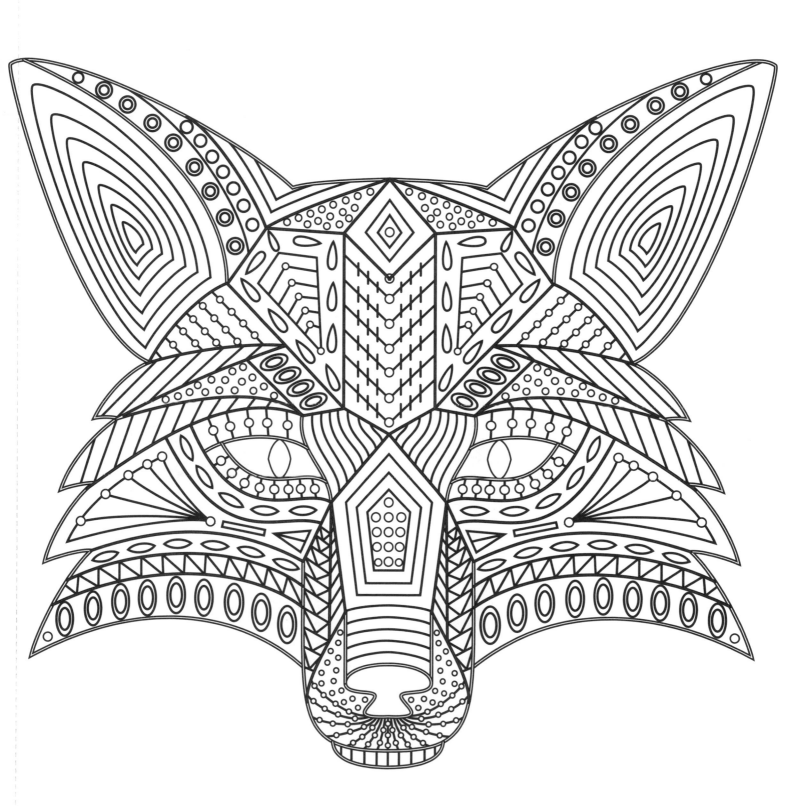

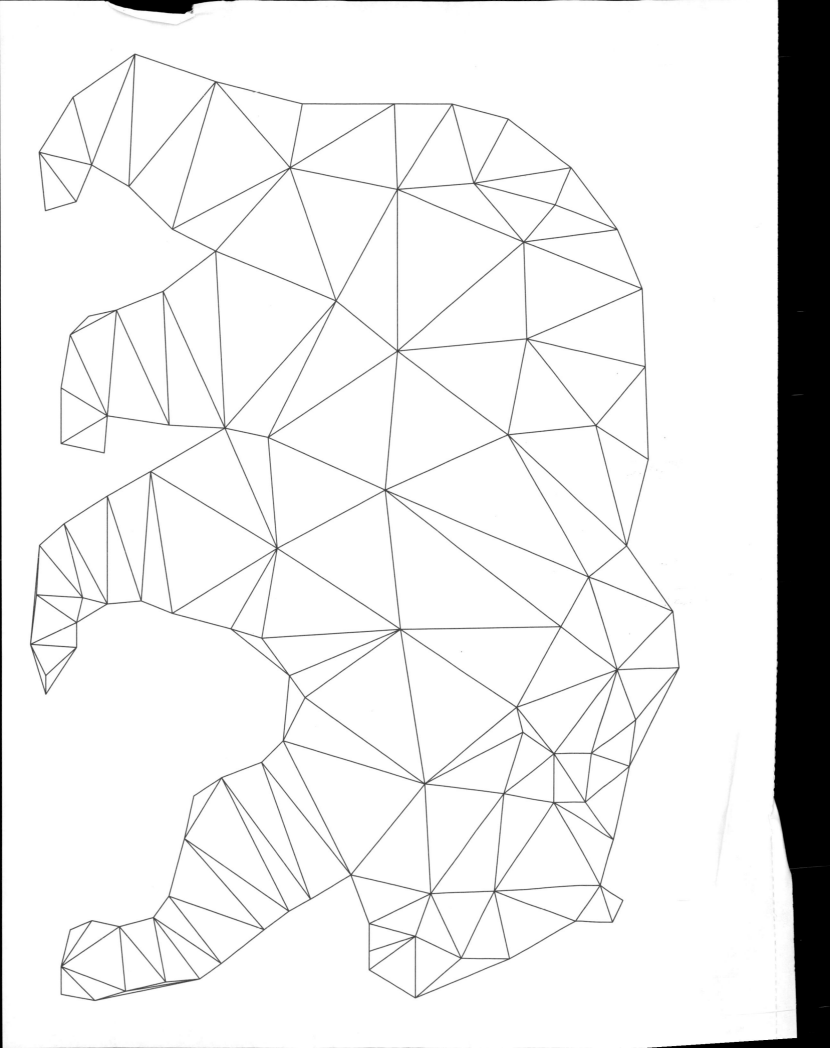

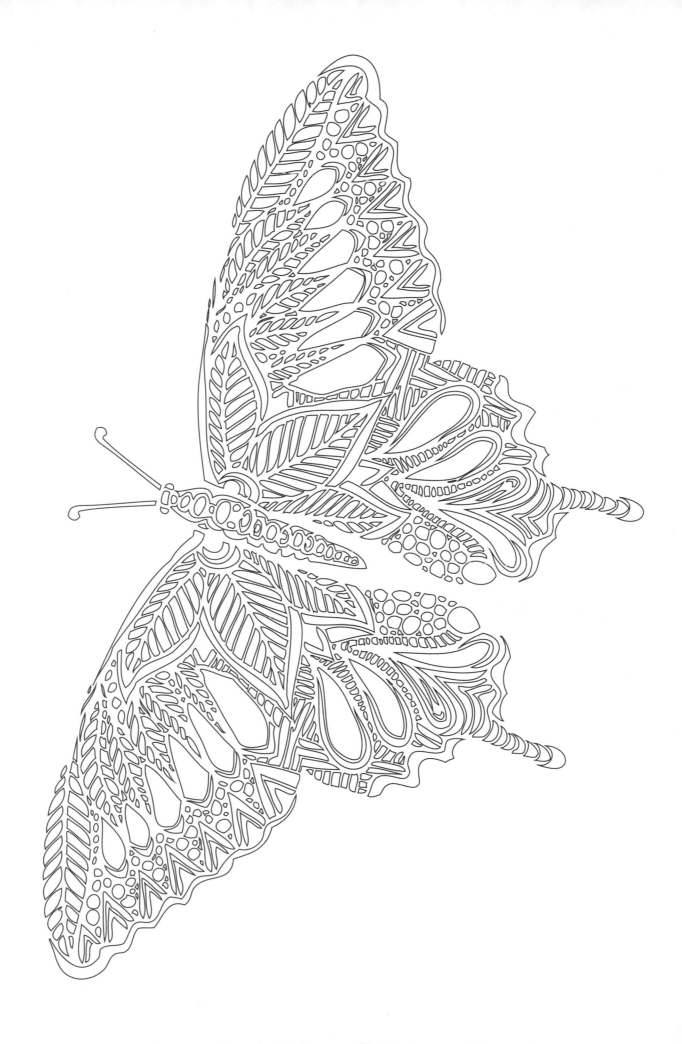

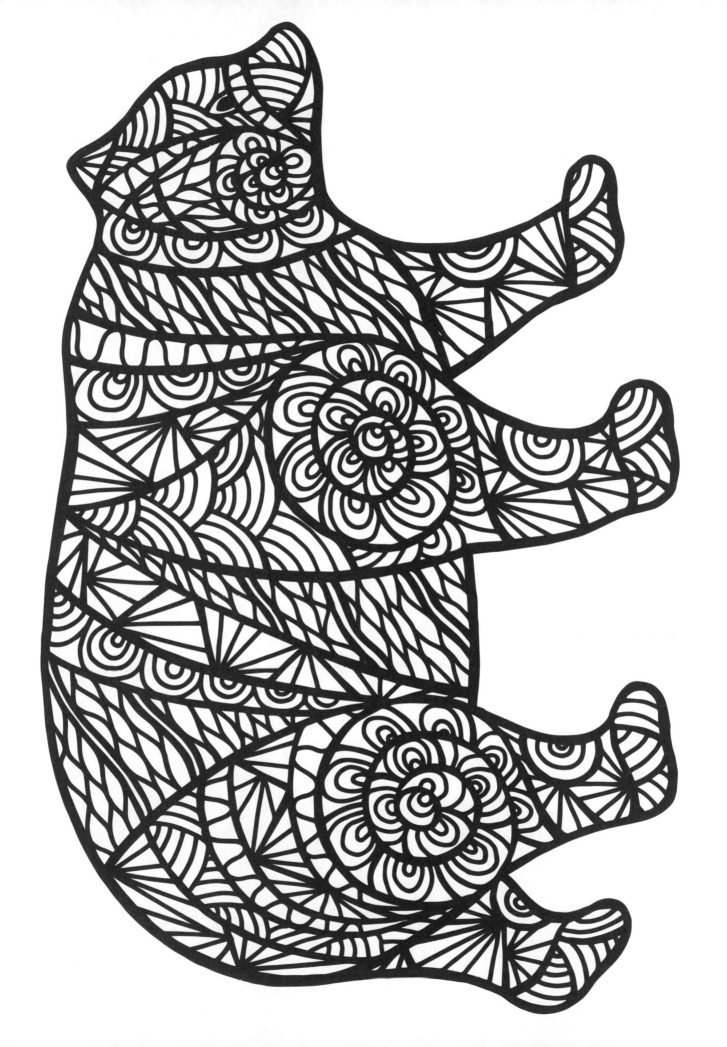

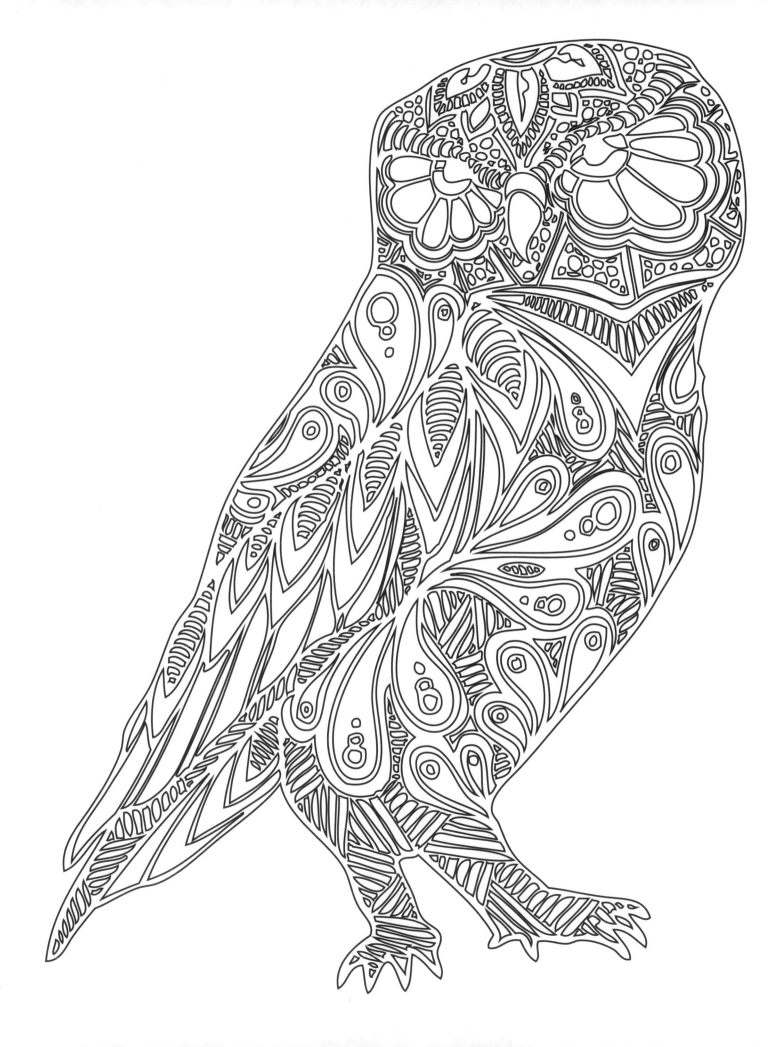

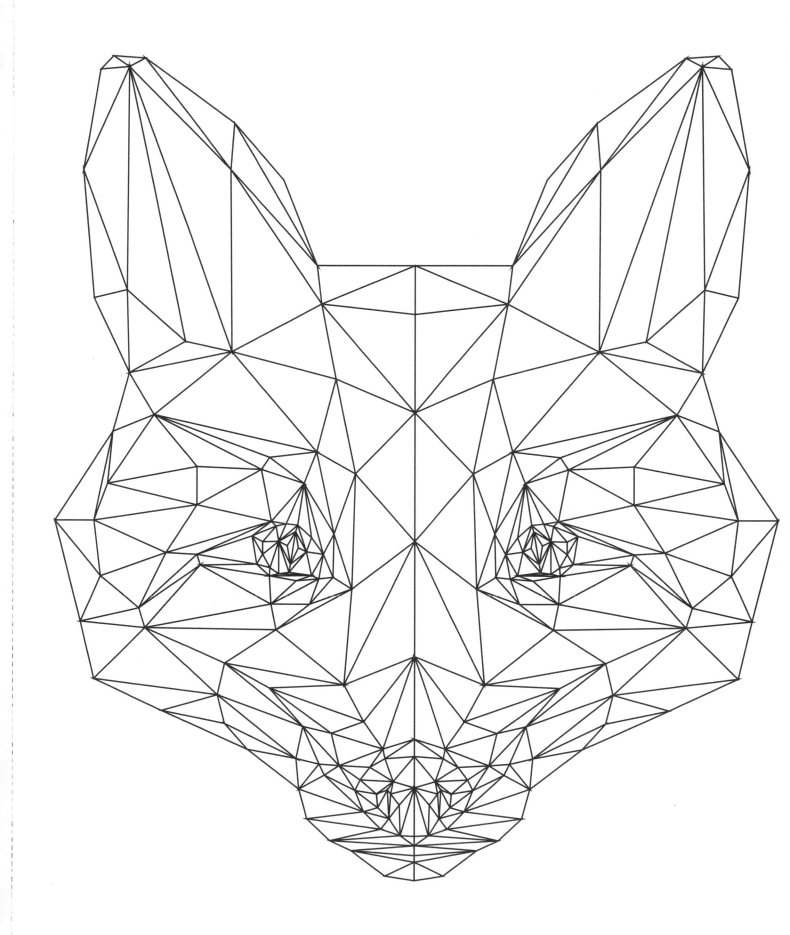

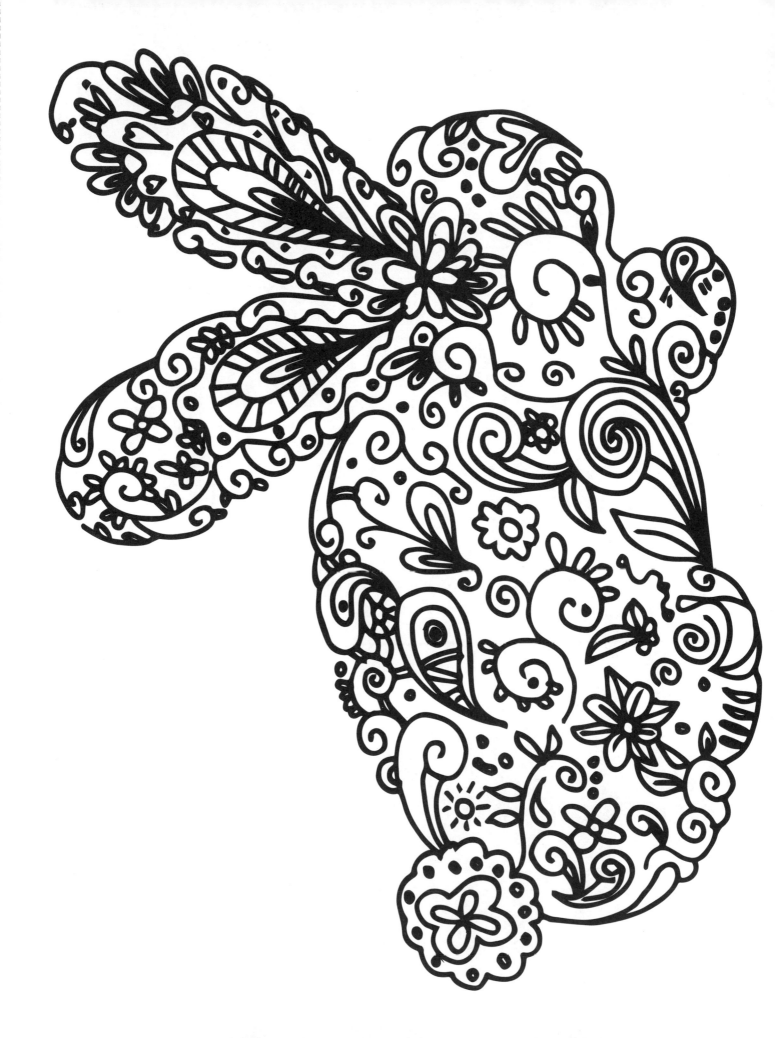

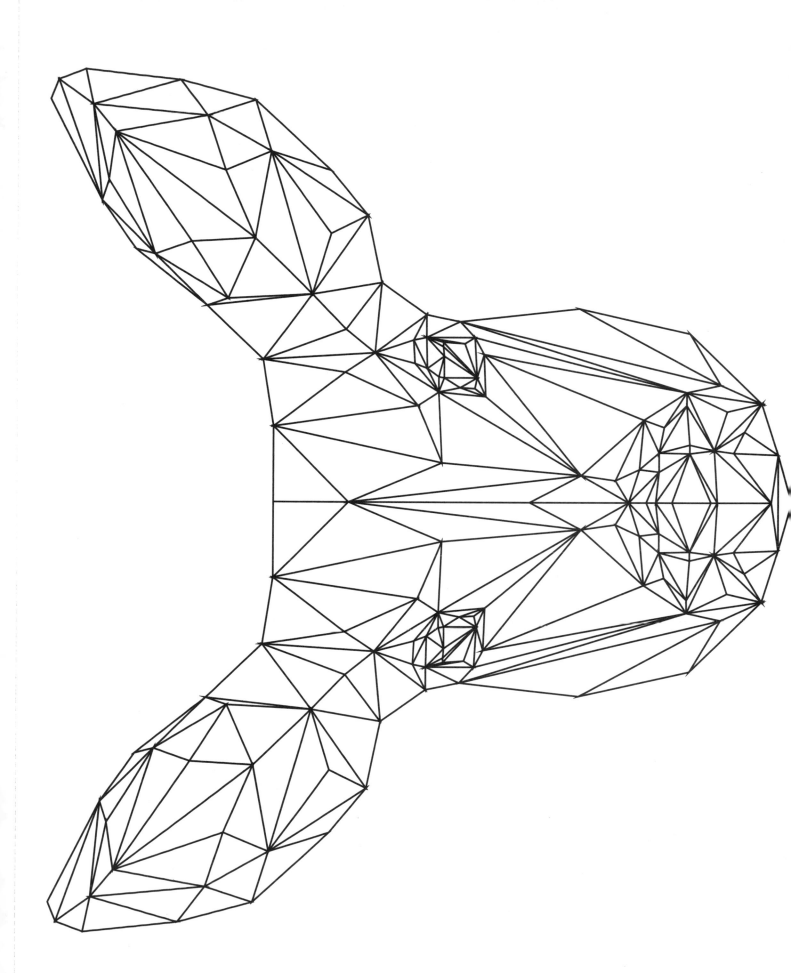

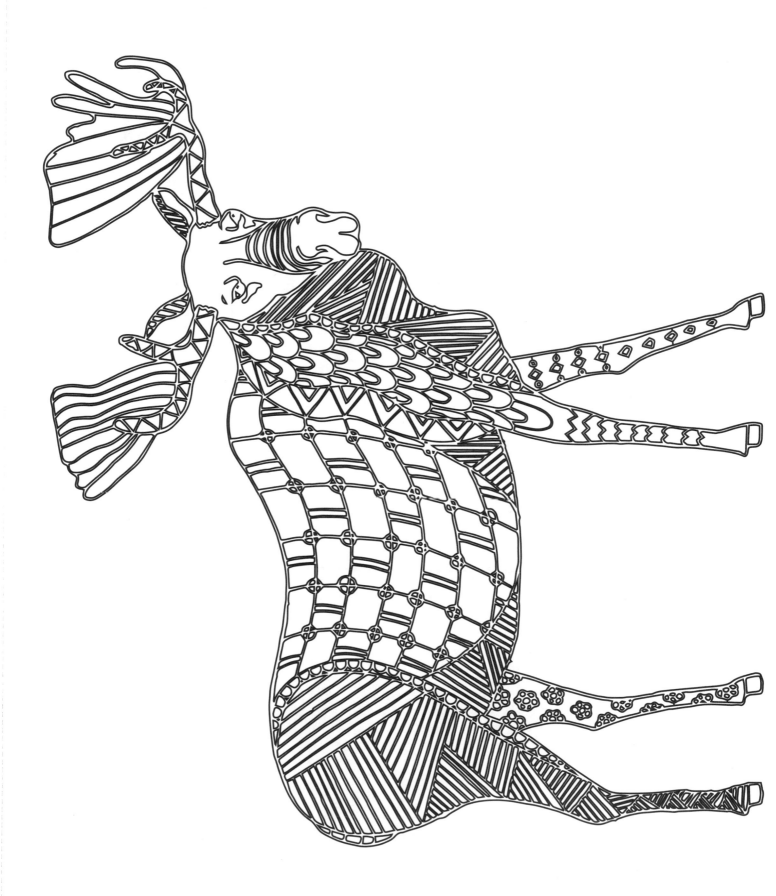

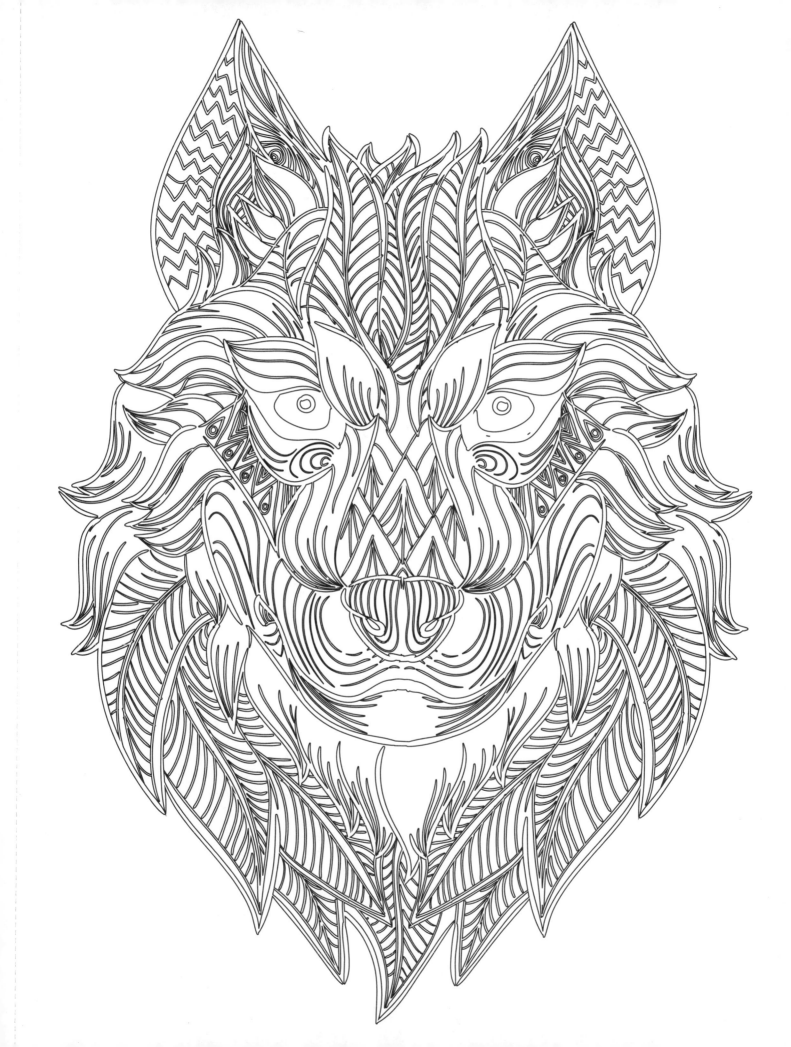

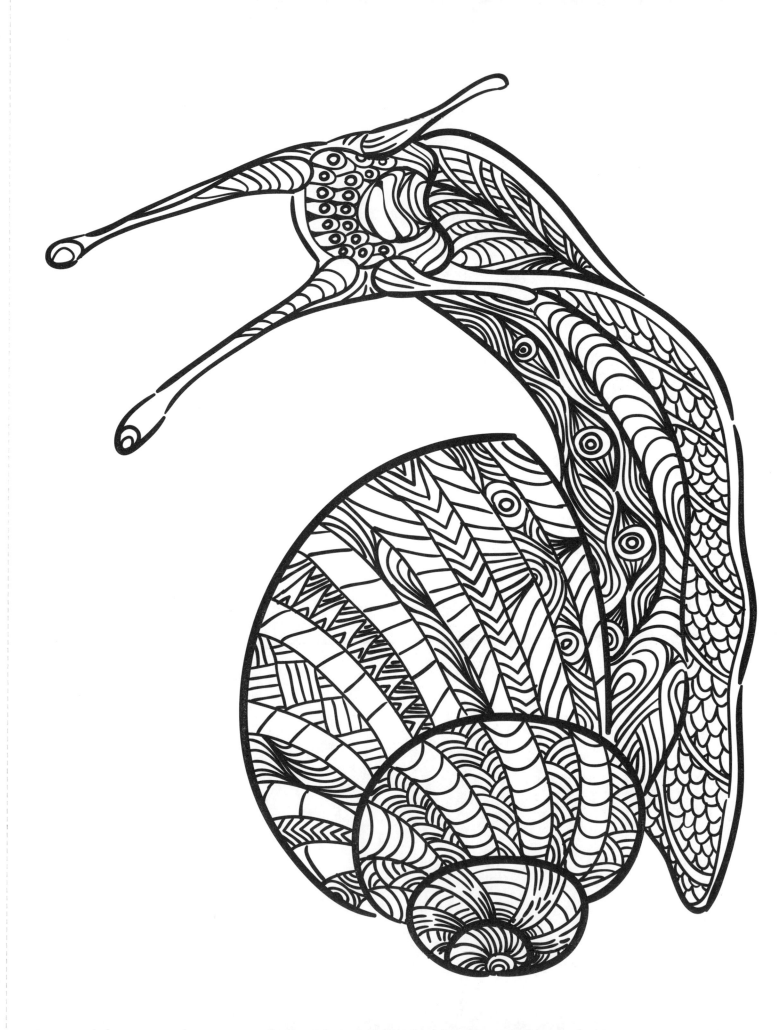

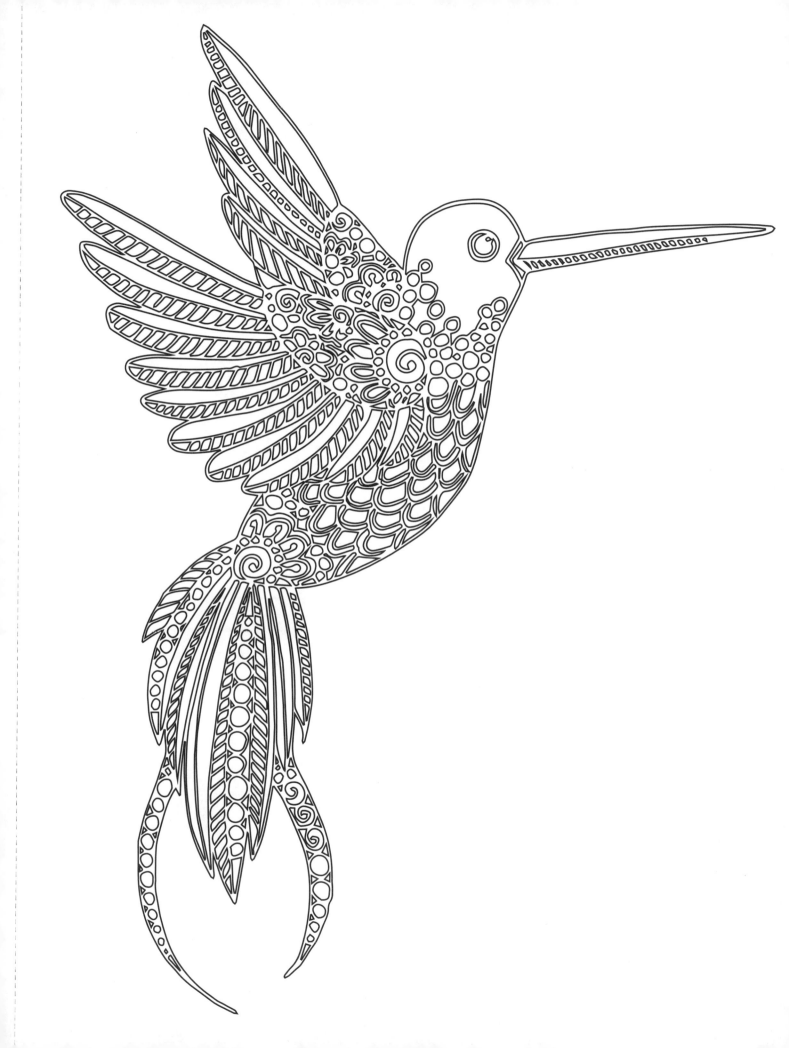

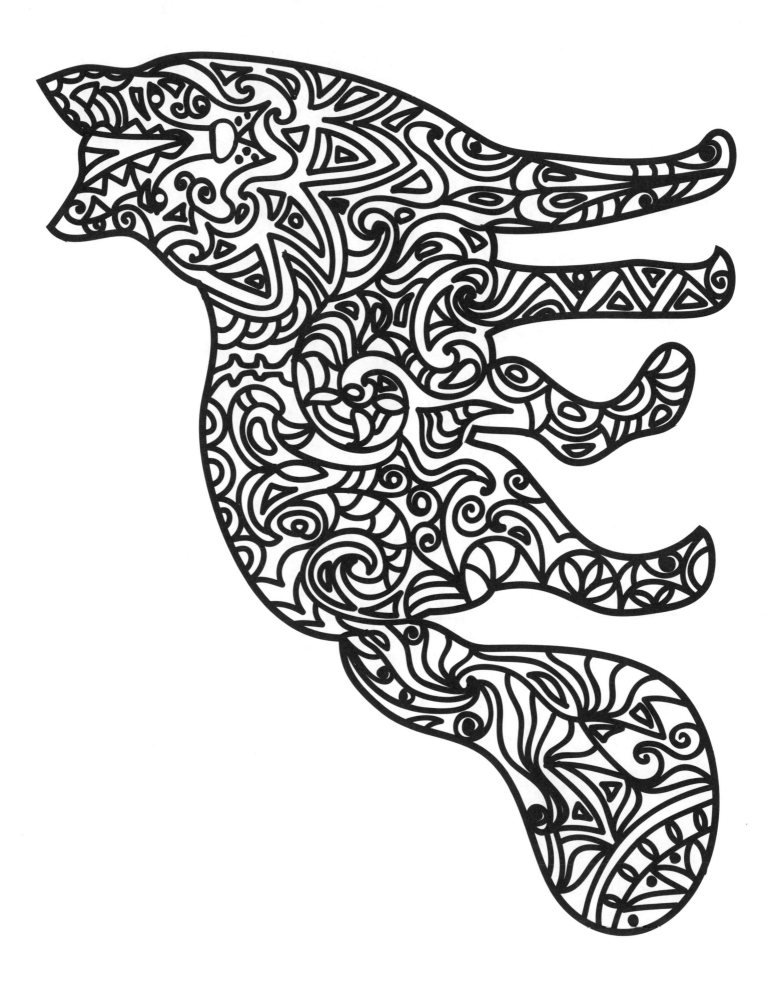

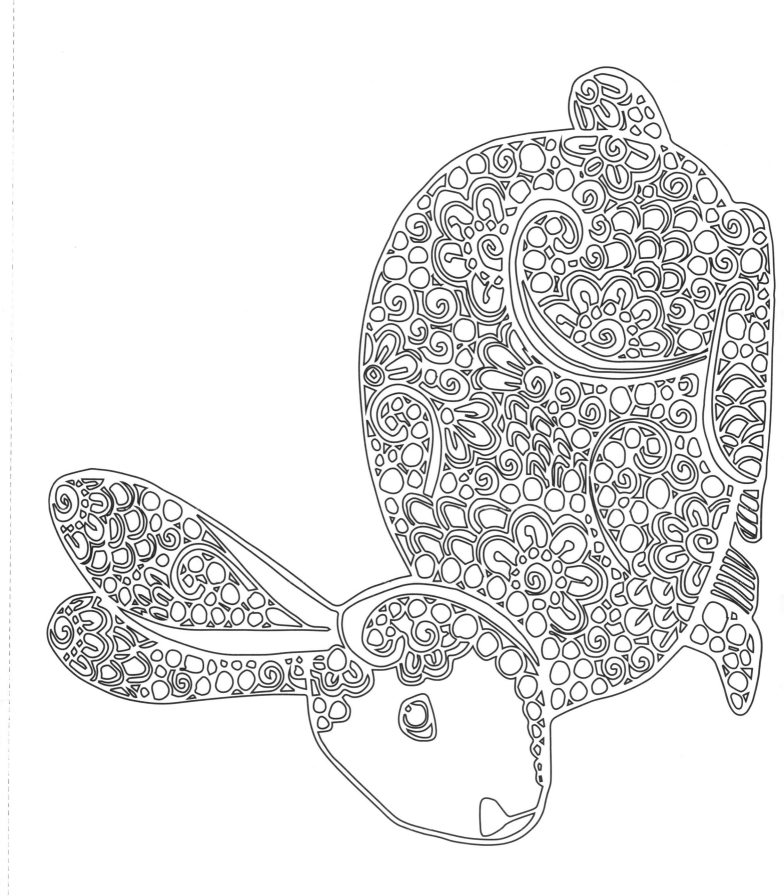

Color Bars

Use these bars to test your coloring medium and palette. Don't be afraid to try unique color combinations!

Color Bars

Color Bars

Also Available from Skyhorse Publishing

Creative Stress Relieving Adult Coloring Book Series
Art Nouveau: Coloring for Artists
Art Nouveau: Coloring for Everyone
Curious Cats and Kittens: Coloring for Artists
Curious Cats and Kittens: Coloring for Everyone
Mandalas: Coloring for Artists
Mandalas: Coloring for Everyone
Mehndi: Coloring for Artists
Mehndi: Coloring for Everyone
Nirvana: Coloring for Artists
Nirvana: Coloring for Everyone
Paisleys: Coloring for Artists
Paisleys: Coloring for Everyone
Tapestries, Fabrics, and Quilts: Coloring for Artists
Tapestries, Fabrics, and Quilts: Coloring for Everyone
Whimsical Designs: Coloring for Artists
Whimsical Designs: Coloring for Everyone
Whimsical Woodland Creatures: Coloring for Artists
Zen Patterns and Designs: Coloring for Artists
Zen Patterns and Designs: Coloring for Everyone

The Dynamic Adult Coloring Books
Marty Noble's Sugar Skulls: Coloring for Everyone
Marty Noble's Peaceful World: Coloring for Everyone

The Peaceful Adult Coloring Book Series
Adult Coloring Book: Be Inspired
Adult Coloring Book: De-Stress
Adult Coloring Book: Keep Calm
Adult Coloring Book: Relax

Portable Coloring for Creative Adults
Calming Patterns: Portable Coloring for Creative Adults
Flying Wonders: Portable Coloring for Creative Adults
Natural Wonders: Portable Coloring for Creative Adults
Sea Life: Portable Coloring for Creative Adults